Gustav Klimt

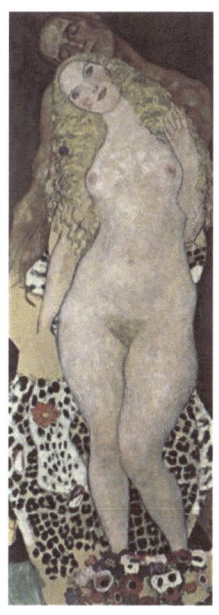

Edited by Lacey Belinda Smith

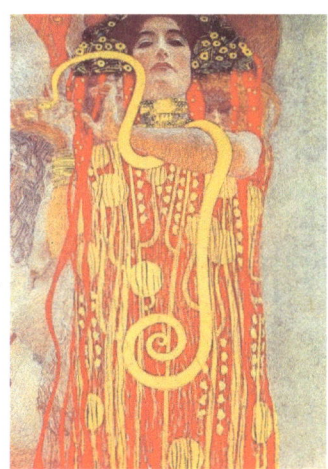

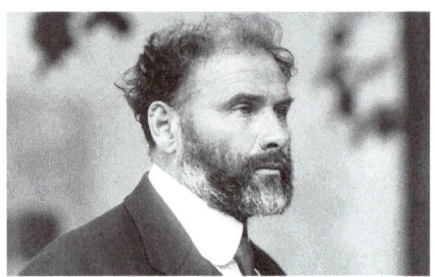

Gustav Klimt (1862 – 1918) was a Nineteenth century Austrian symbolist painter and one of the most conspicuous members of the Vienna Secession movement. Klimt is noted for his paintings, murals, sketches, and other objets d'art. Klimt's primary subject was the female body, and his works are risqué which were seen as a rebellion against the traditional academic art of his time. *The Kiss* and *Portrait of Adele Bloch-Bauer* are his most famous works. Klimt died in the influenza epidemic of 1918, leaving behind a posthumous legacy.

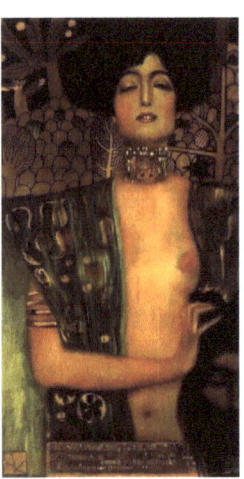

"Whoever wants to know something about me—as an artist, the only notable thing—ought to look carefully at my pictures and try to see in them what I am and what I want to do."

—Gustav Klimt

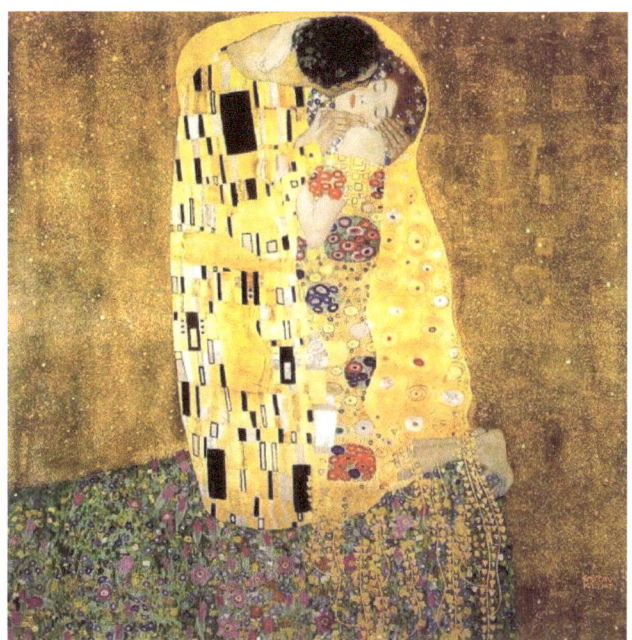

The Kiss--1907-1908-- Art Nouveau (Modern)

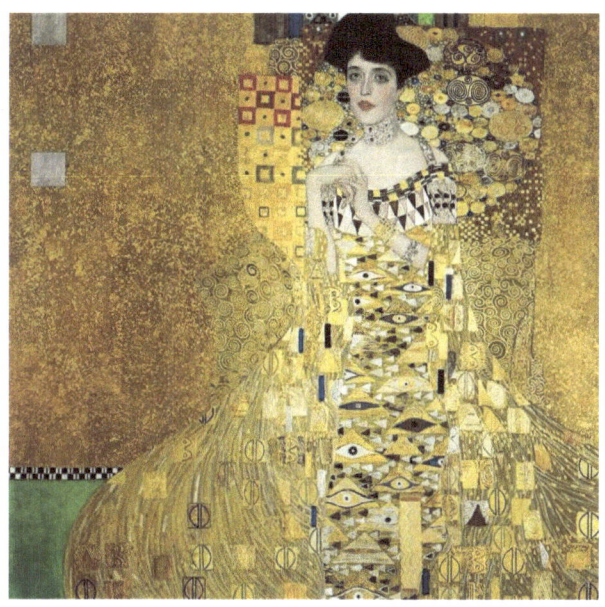

Portrait Of Adele Bloch-Bauer I—1907-- Art Nouveau (Modern)

It has been referred to as the final and most fully representative work of his golden phase. Adele Bloch-Bauer was a wealthy society woman and hostess of a renowned Viennese Salon at the beginning of the twentieth century.

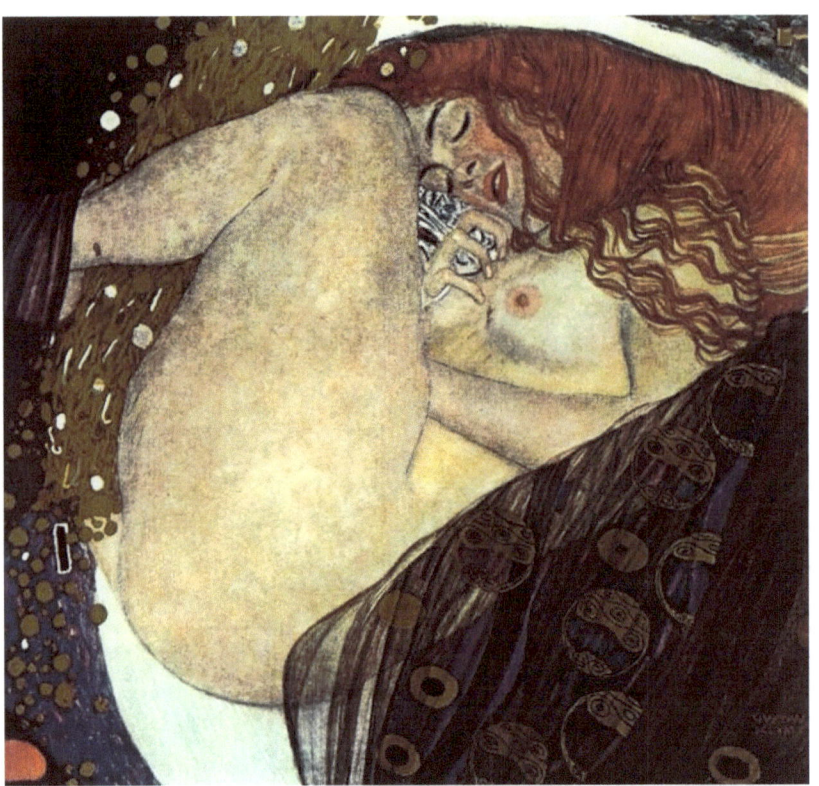

Danae--1907-1908-- Art Nouveau (Modern)

Danae was the symbol of divine love, transcendence, and sensational beauty in Greek mythology. She was the daughter and only child of King Acrisius of Argos and his wife Queen Eurydice.

Acrisius was disappointed that he had no sons to give his throne, and he asked an oracle for help. The answer he got was that his grandson would kill him. At that point, Danae was childless, and to keep the prophecy from coming true, Acrisius locked her away in a tower. However, Zeus had seen Danae and wanted to have sex with her. As a result, during the night, he appeared to her in the form of golden rain and flowing in between her legs. Soon after Zeus' visit, Danae became pregnant and gave birth to her son Perseus.

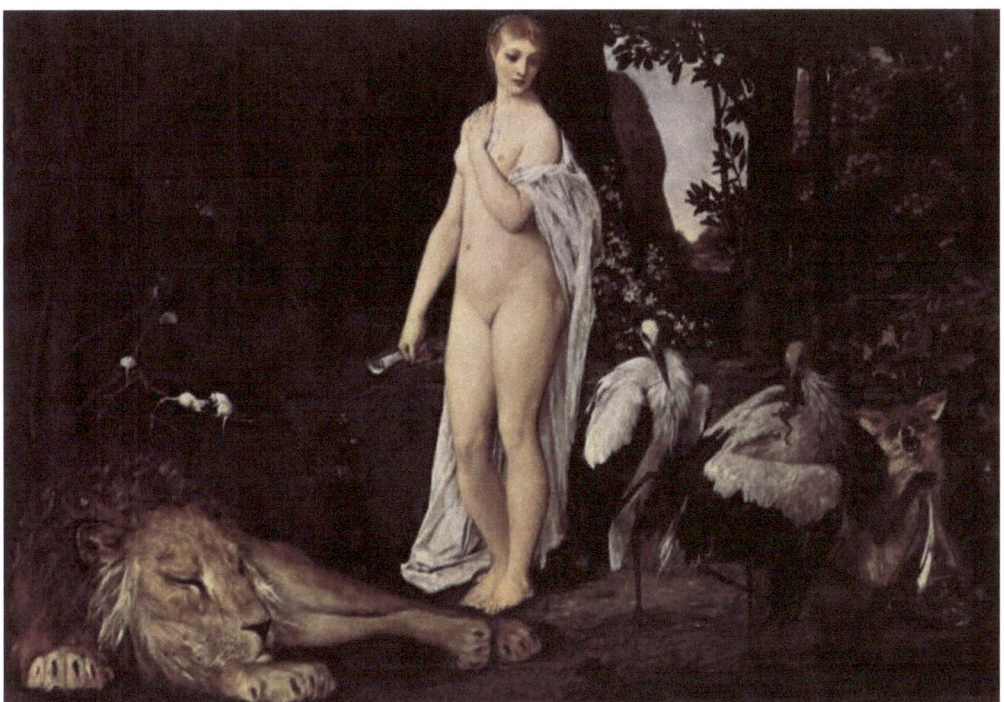

Fable—1883-- Neoclassicism

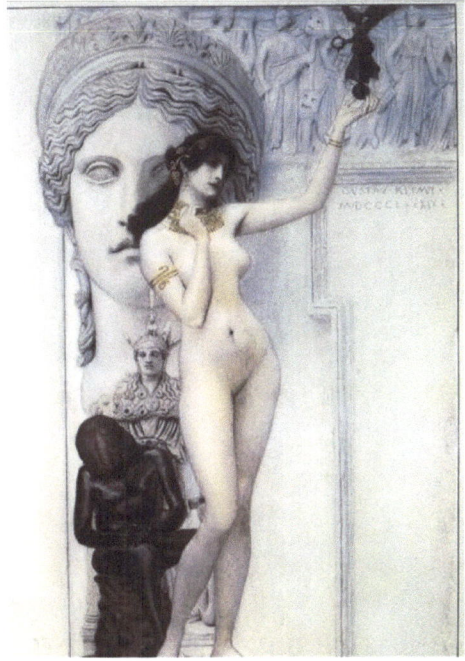

Allegory Of Sculpture—1889-- Art Nouveau (Modern)

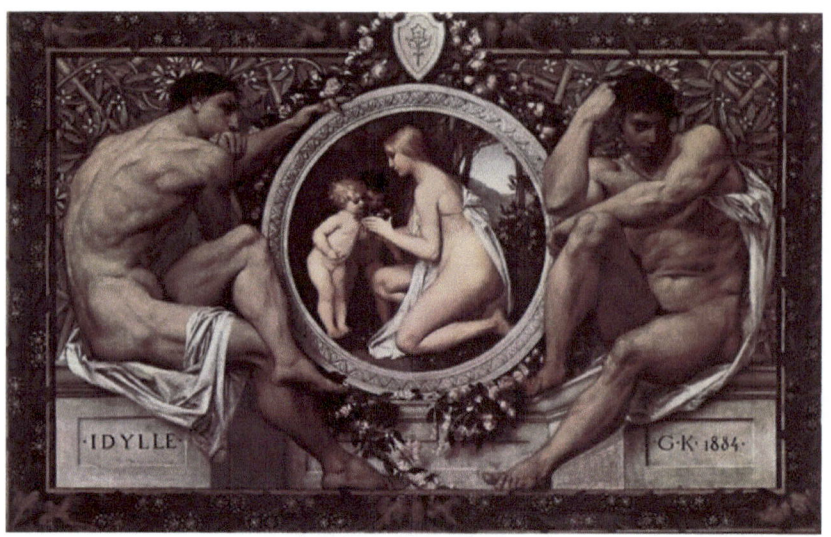

Idylle (Idylls)—1884-- Neoclassicism

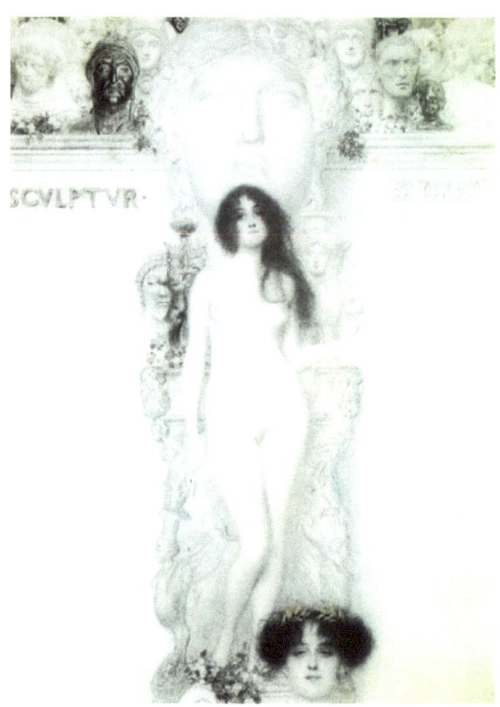

Sculpture—1896-- Art Nouveau (Modern)

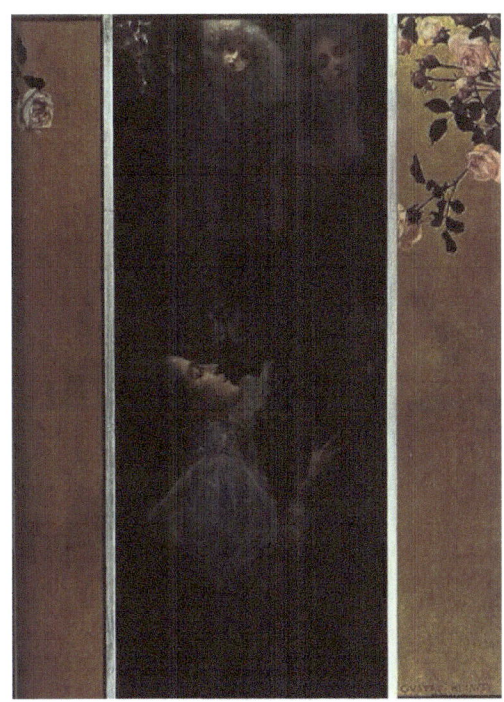

Love—1895-- Symbolism

Sappho--1888-1890-- Romanticism

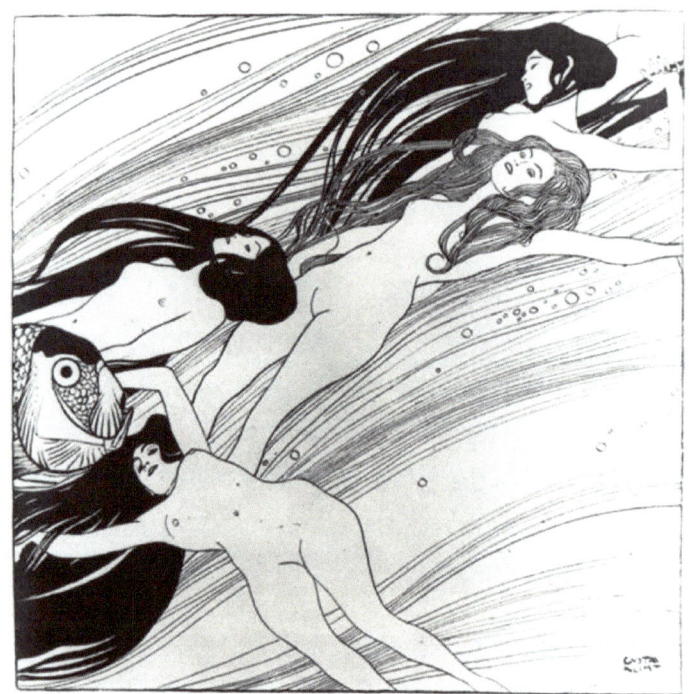

Fishblood—1898-- Symbolism

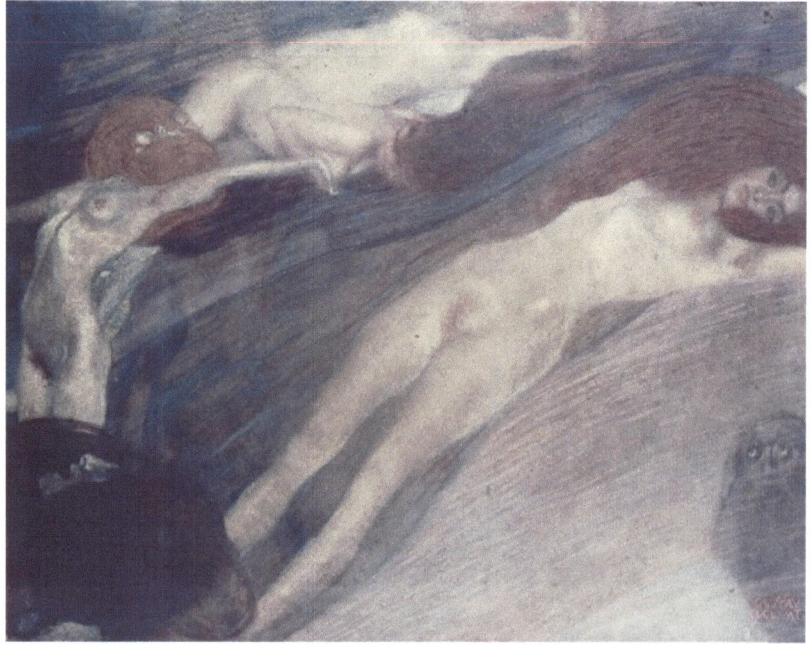

Bewegte Wasser—1898--Symbolism

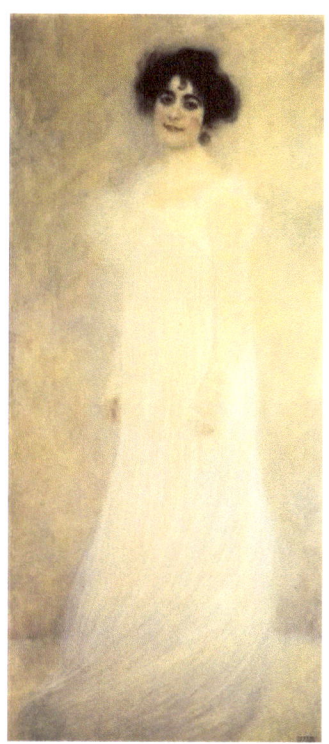

Portrait Of Serena Lederer—1899--Symbolism

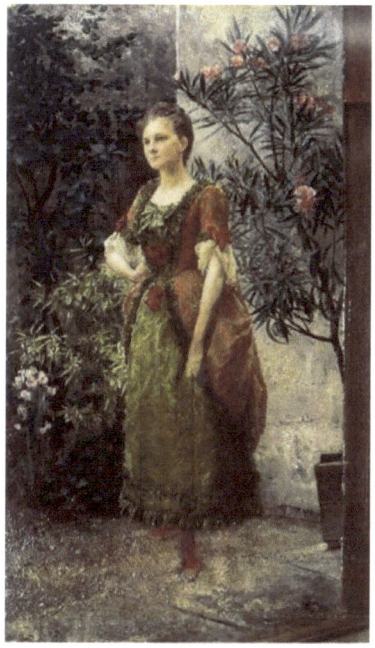

Portrait Of Emilie Flöge—1893-- Symbolism

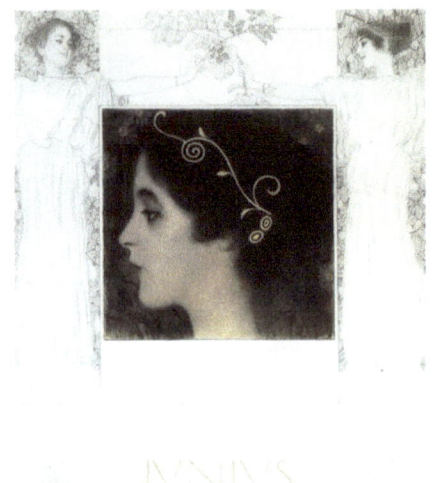

Junius—1896-- Symbolism

Painted Composition Draft Jusisprudenz

Originally Titled Gemalter Kompositionsentwurf zur Jusisprudenz

1897-1898--Symbolism

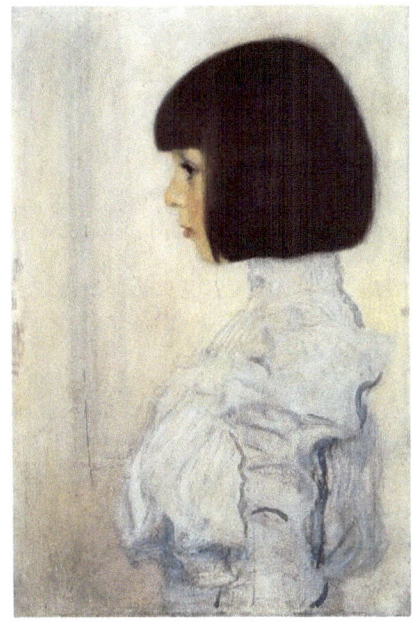

Portrait Of Helene Klimt—1898-- Symbolism

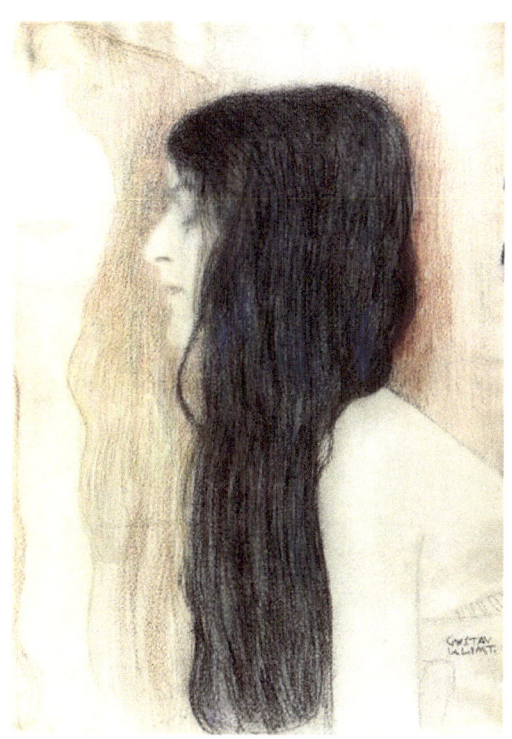

Girl With Long Hair, With A Sketch For 'Nude Veritas'--1898-1899-- Symbolism

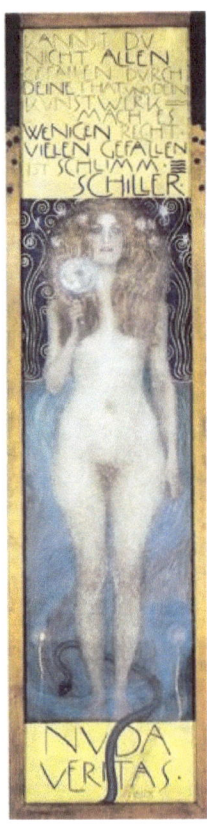

Nuda Veritas—1899-- Art Nouveau (Modern)

Study For Philosophy--1898-1899--Art Nouveau (Modern)

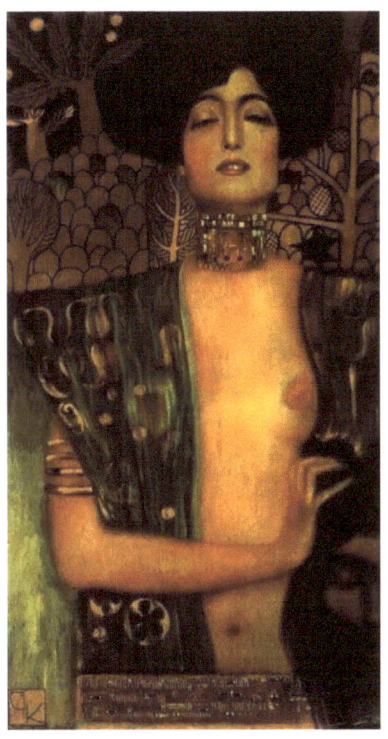

Judith And Holopherne—1901--Art Nouveau (Modern)

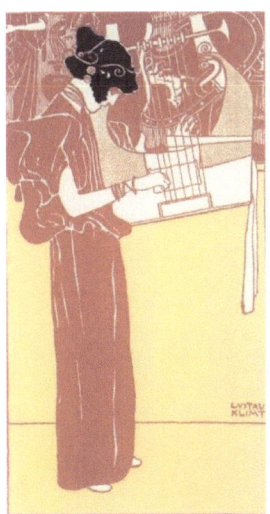

Musik (Lithograph)—1901--Art Nouveau (Modern)

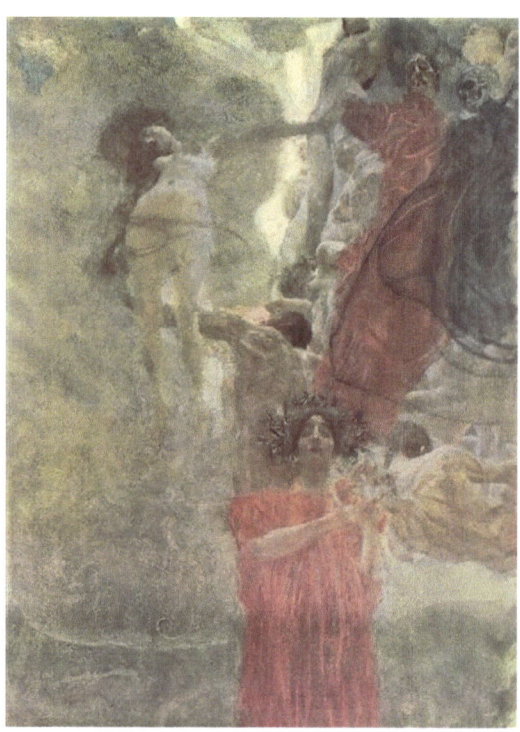

Painted Composition Design To Medicine

Originally Titled Gemalter Kompositionsentwurf zur Medizin

1887-1888-- Symbolism

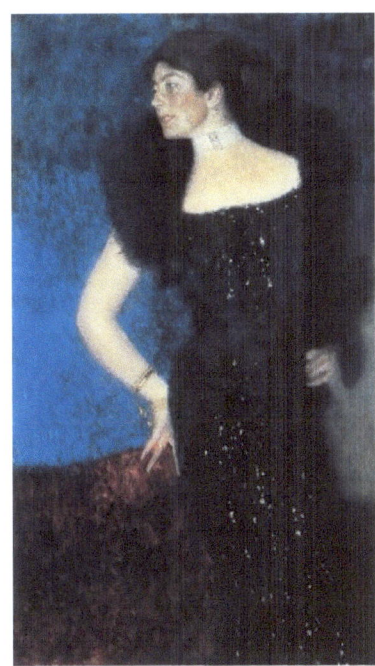

Portrait Of Rose Von Rosthorn-Friedmann-- 1900-1901-- Symbolism

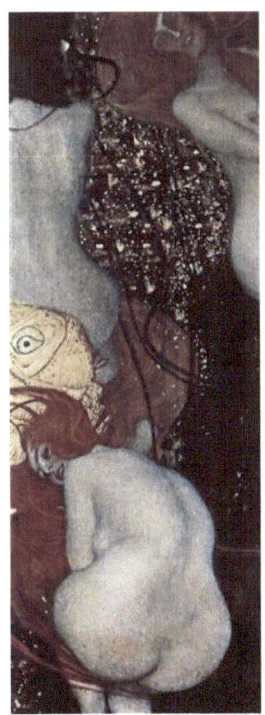

Goldfish-- 1901-1902--Symbolism

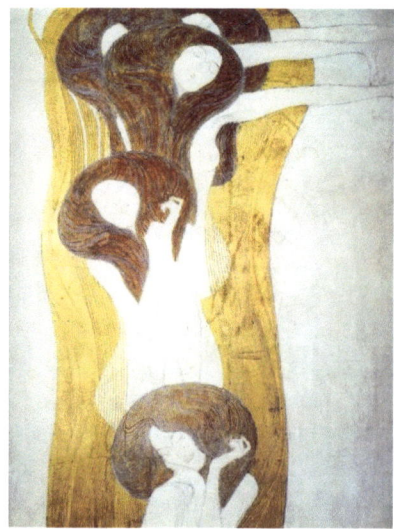

The Beethoven Frieze: The Longing For Happiness Finds Repose In Poetry. Right Wall, Detail—1902-- Art Nouveau (Modern)

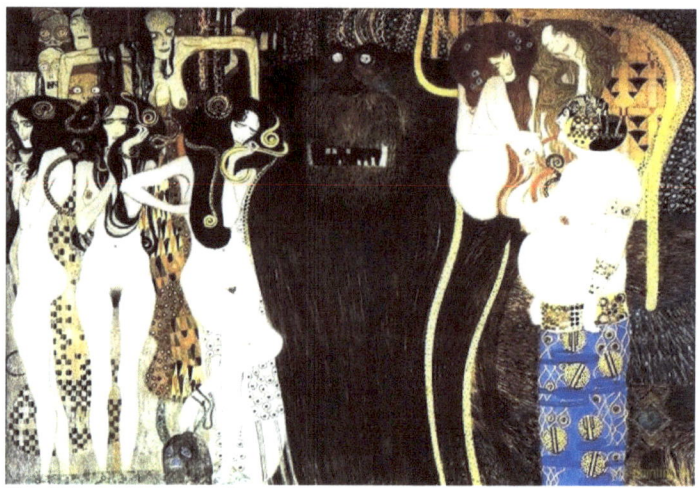

The Beethoven Frieze: The Hostile Powers. Left Part, Detail—1902--Art Nouveau (Modern)

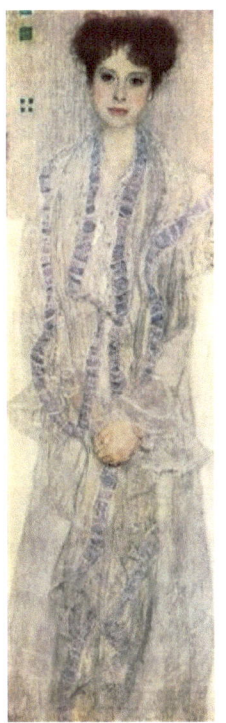

Portrait Of Gertha Felssovanyi—1902--Symbolism

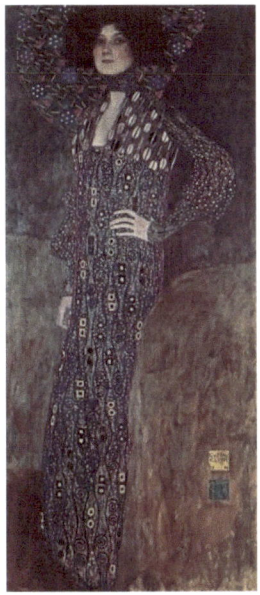

Portrait Of Emilie Flöge—1902-- Art Nouveau (Modern)

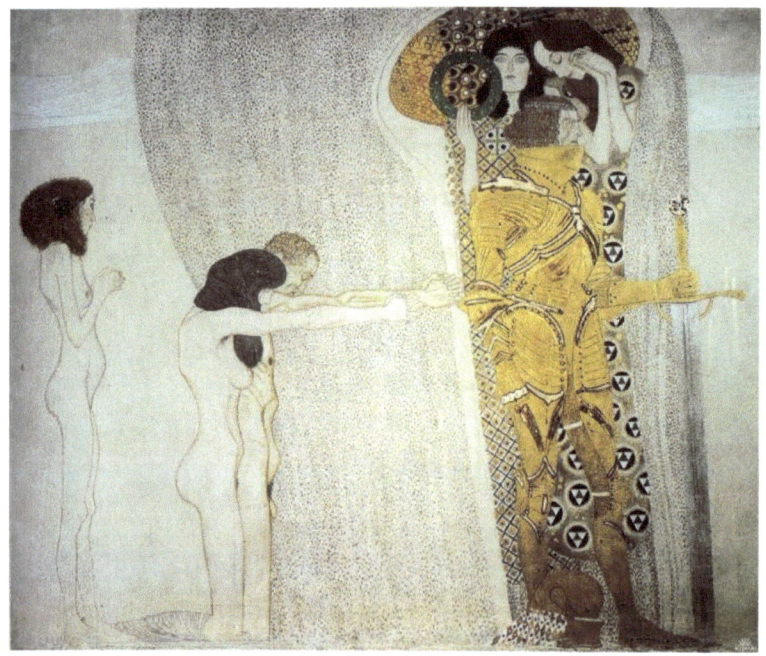

The Beethoven Frieze: The Longing For Happiness. Left Wall—1902--Art Nouveau (Modern)

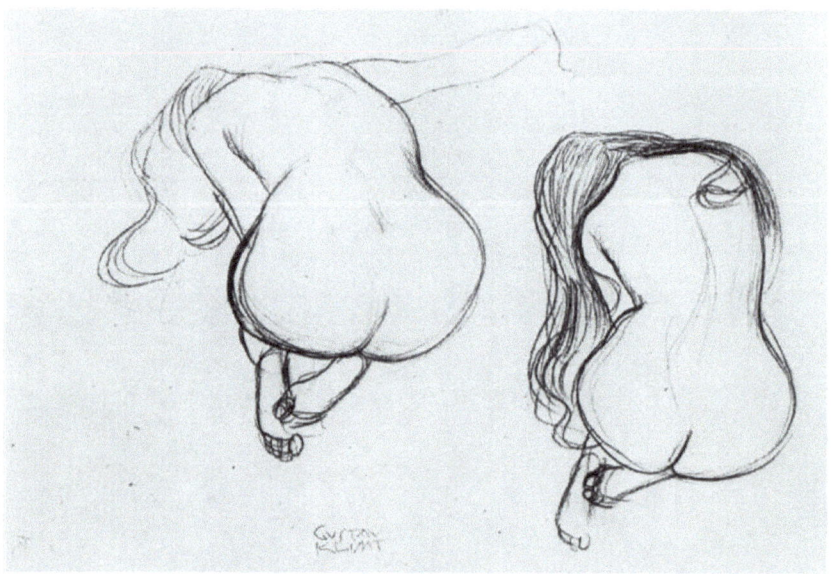

Two Studies Of Sitting Nudes--1901-1902-- Symbolism

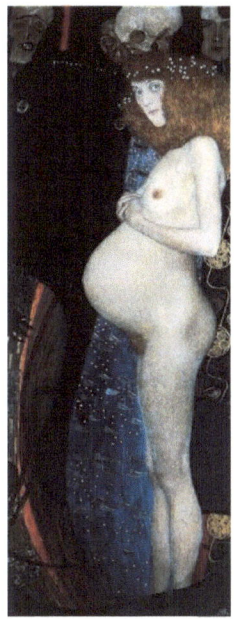

Hope I—1903-- Symbolism

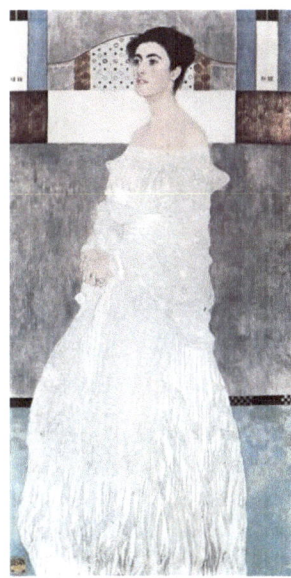

Portrait Of Margaret Stonborough-Wittgenstein—1905--Symbolism

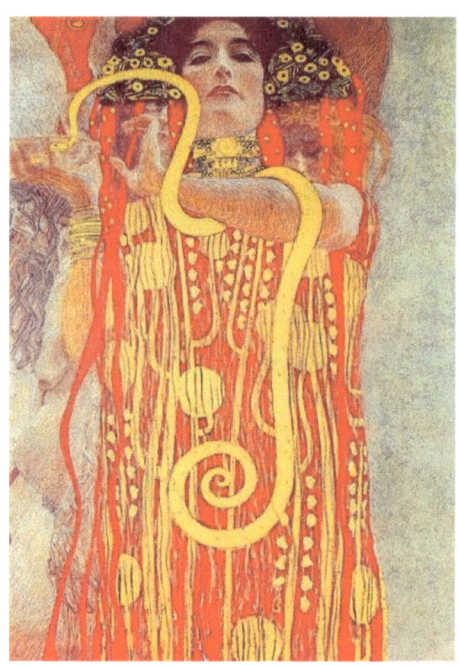

University Of Vienna Ceiling Paintings (Medicine), Detail Showing Hygieia

1900-1907-- Art Nouveau (Modern)

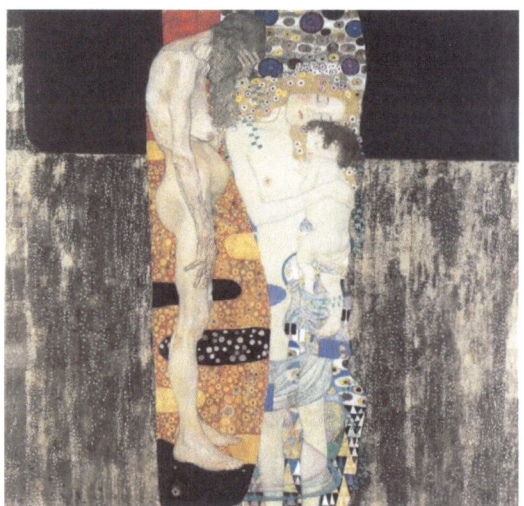

The Three Ages Of Woman

Originality Titled Die drei Lebensalter der Frau—1905--Art Nouveau (Modern)

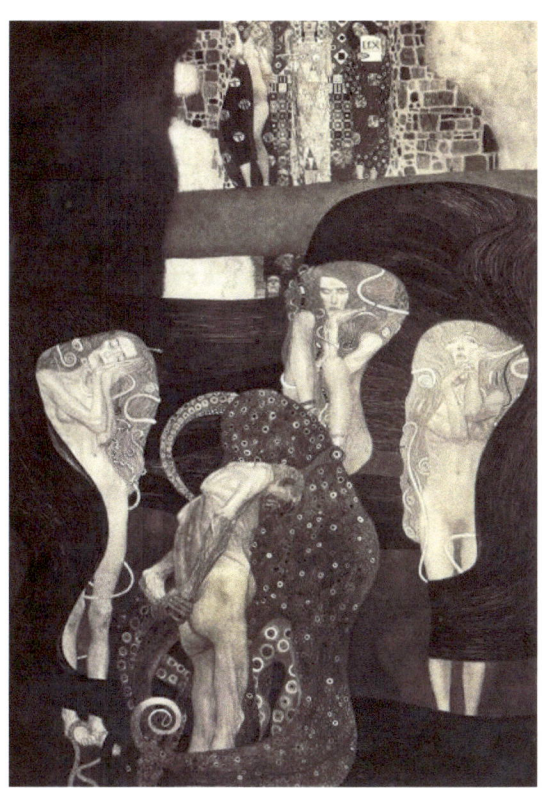

Jurisprudence (Final State) -- 1903-1907-- Art Nouveau (Modern)

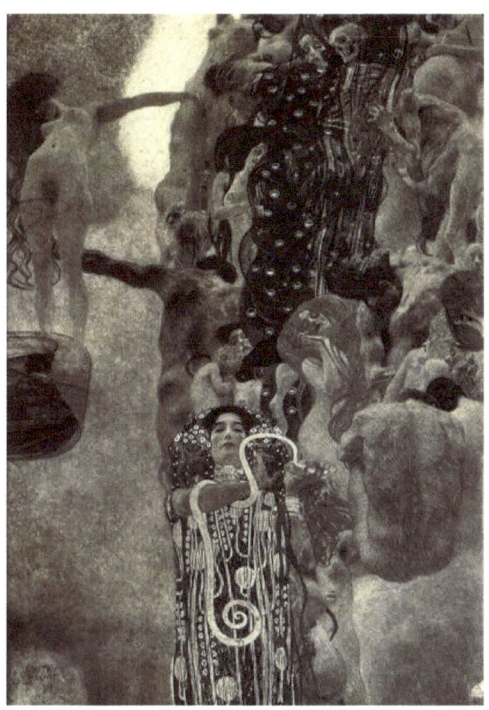

University Of Vienna Ceiling Paintings (Medicine), Final State-- 1900-1907

Art Nouveau (Modern)

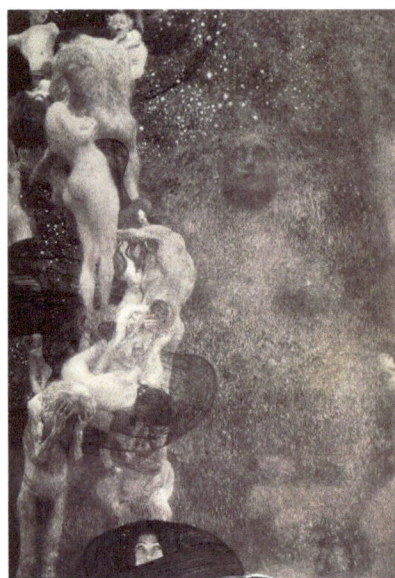

Philosophy (Final State)--1899-1907-- Art Nouveau (Modern)

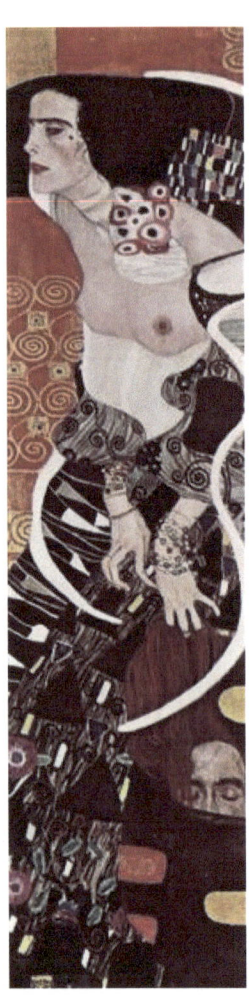

Judith II (Salome)—1909-- Art Nouveau (Modern)

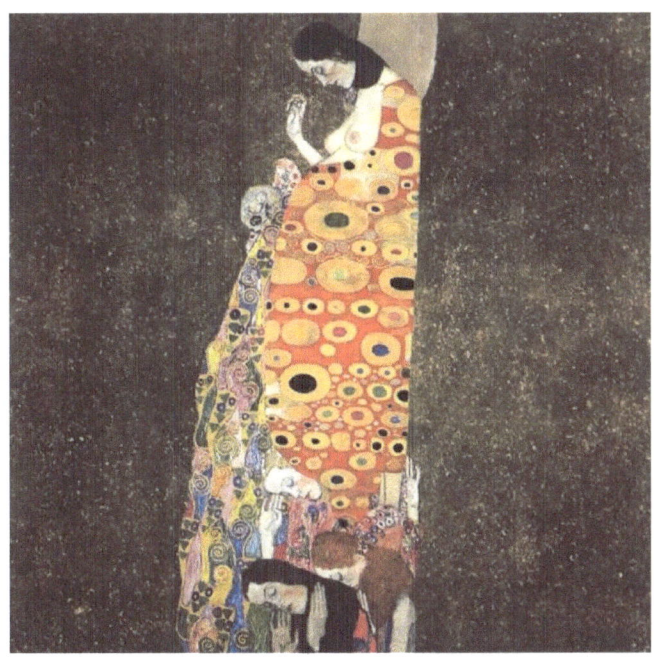

Hope II-- 1907-1908-- Art Nouveau (Modern)

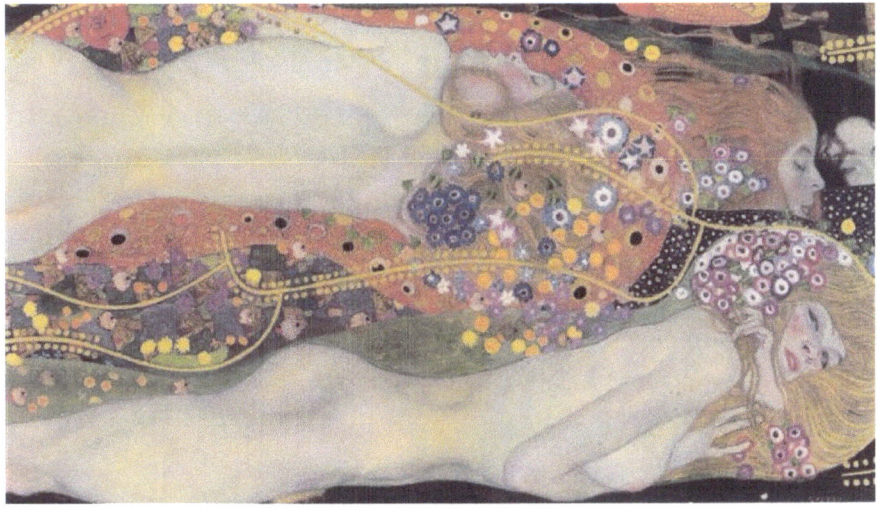

Water Snakes II—1907-- Art Nouveau (Modern)

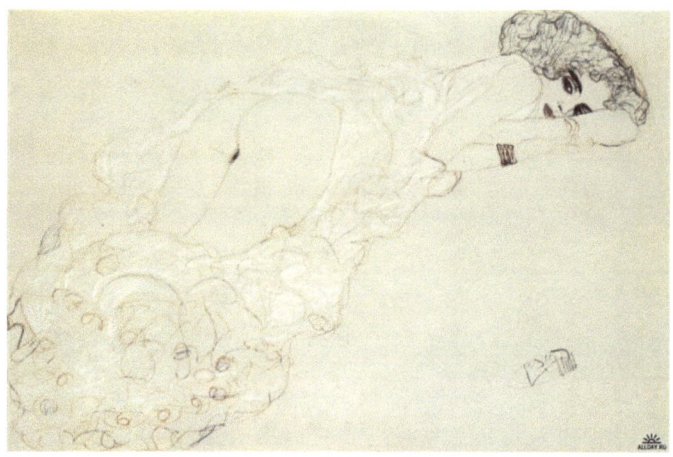

Reclining Nude Lying On Her Stomach And Facing Right--1910

Art Nouveau (Modern)

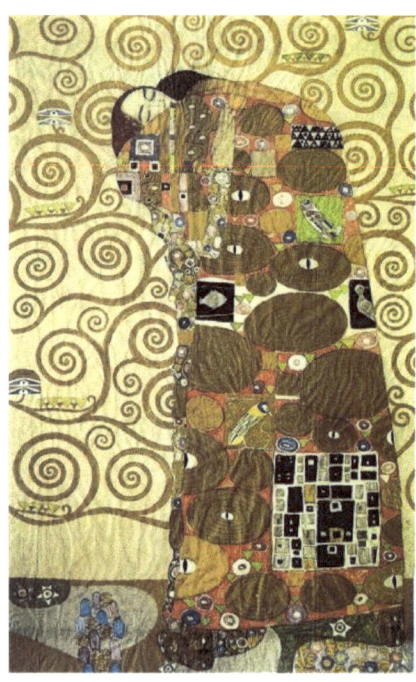

Cartoon For The Frieze Of The Villa Stoclet In Brussels: Fulfillment

1905-1909-- Art Nouveau (Modern)

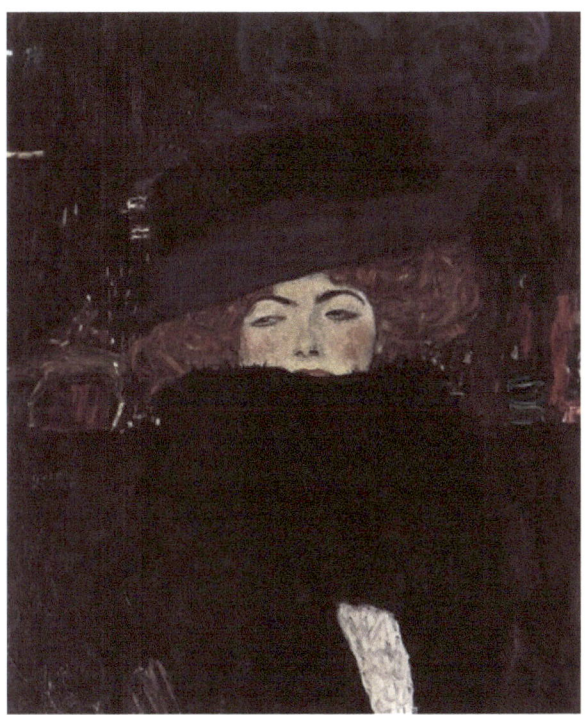

Lady With Hat And Featherboa—1909-- Art Nouveau (Modern)

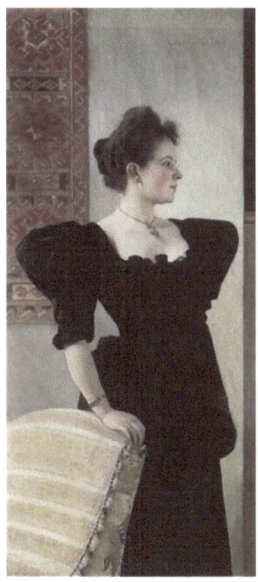

Portrait Of Marie Breunig—1894-- Realism

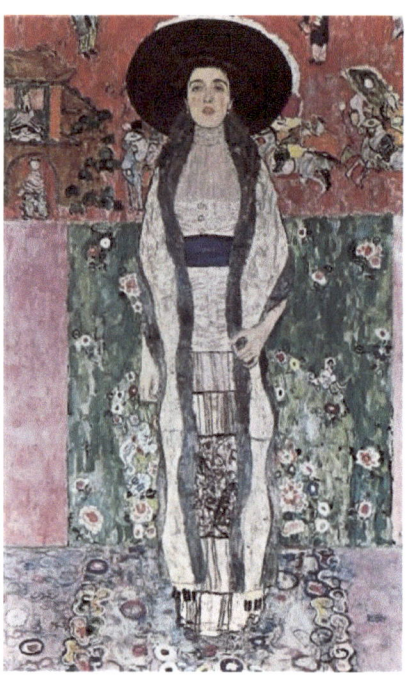

Portrait Of Adele Bloch-Bauer II—1912-- Art Nouveau (Modern)

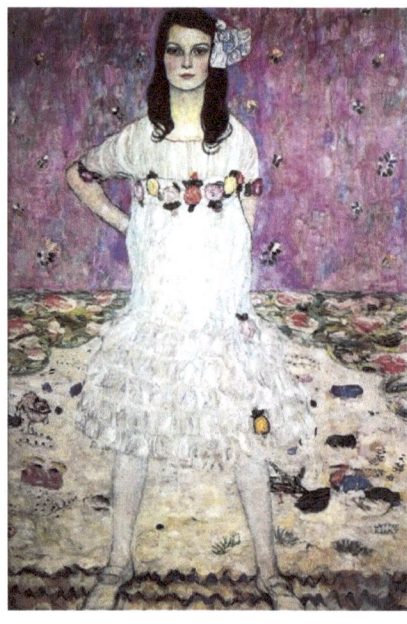

Mada Primavesi—1912-- Symbolism

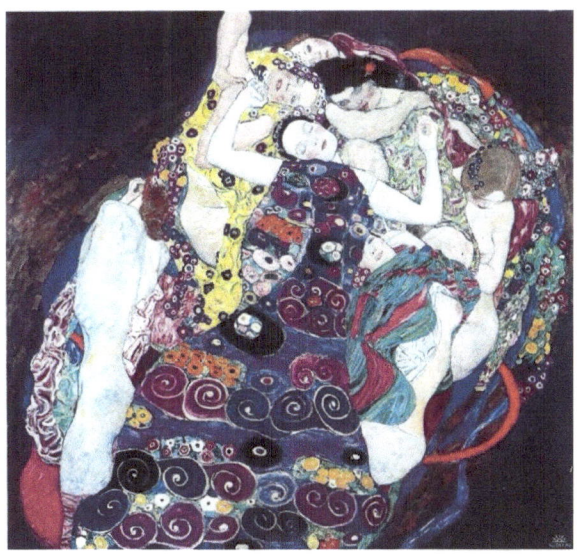

The Virgin—1913-- Art Nouveau (Modern)

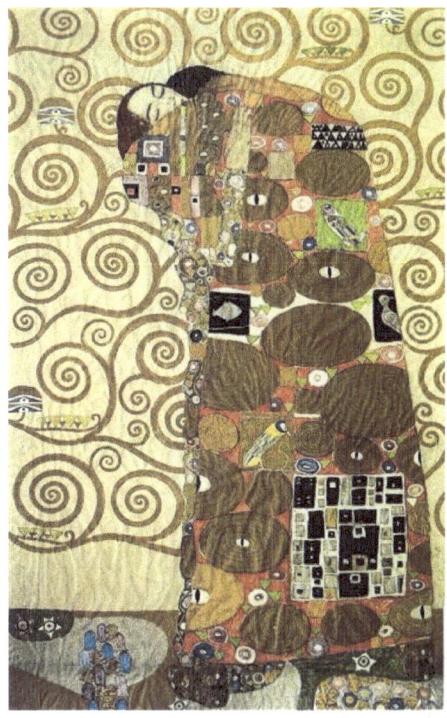

Cartoon For The Frieze Of The Villa Stoclet In Brussels: Fulfillment--1905-1909-- Art Nouveau (Modern)

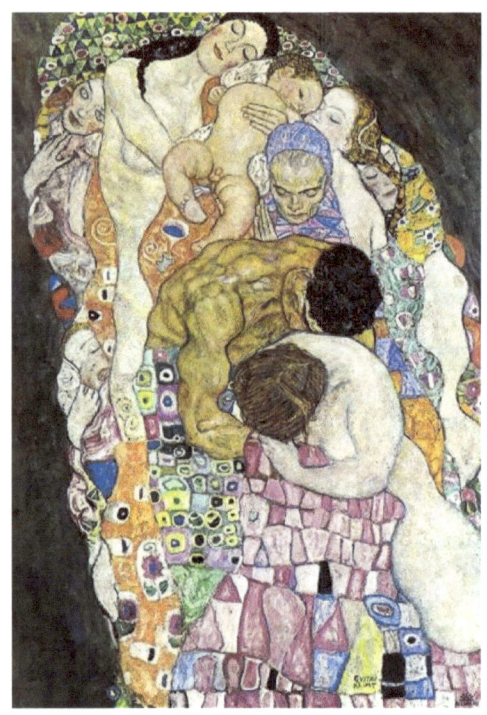

Death And Life-- 1908-1916-- Art Nouveau (Modern)

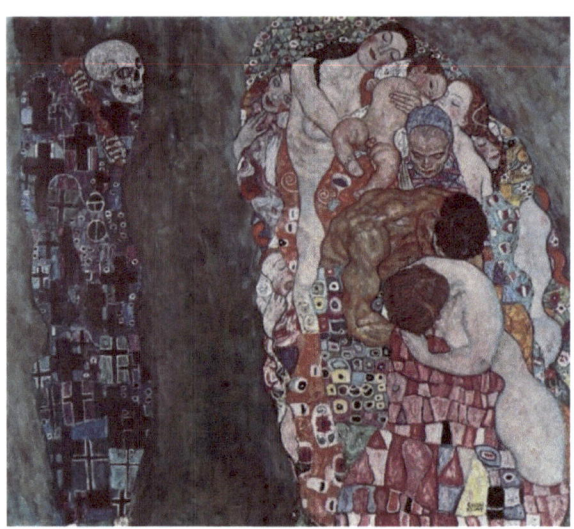

Death And Life-- 1908-1916-- Art Nouveau (Modern)

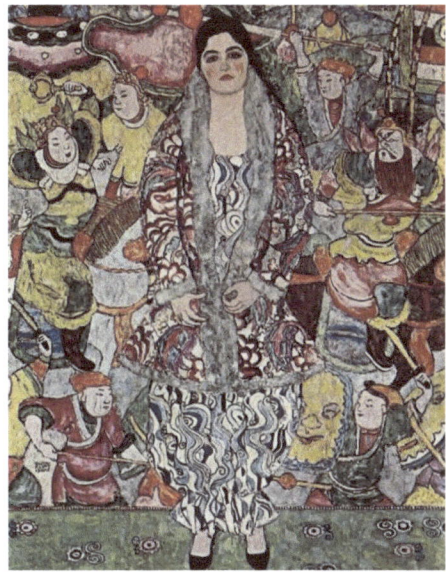

Fredericke Maria Beer—1916--Art Nouveau (Modern), Japonism

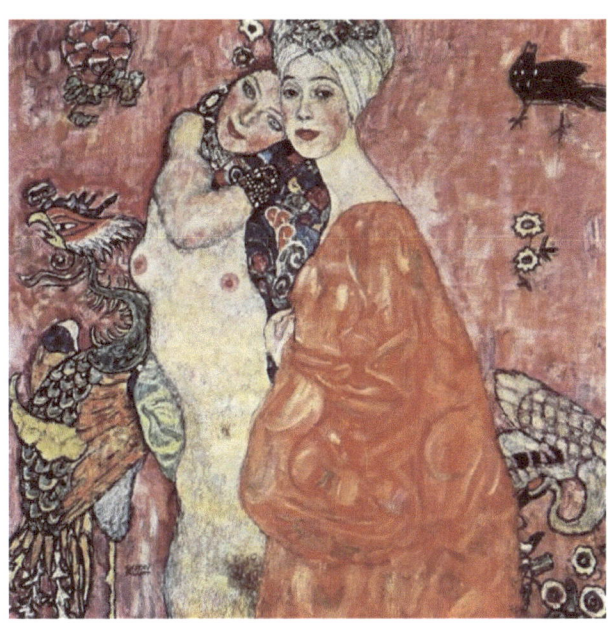

The Women Friends-- 1916-1917-- Art Nouveau (Modern)

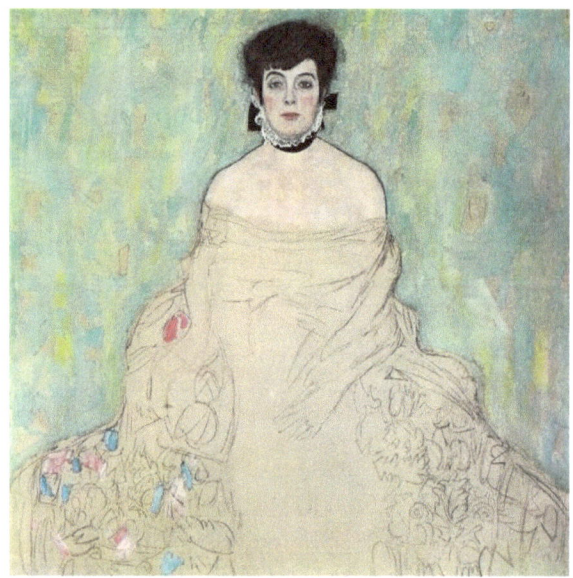

Amalie Zuckerkandl--1917-1918-- Art Nouveau (Modern)

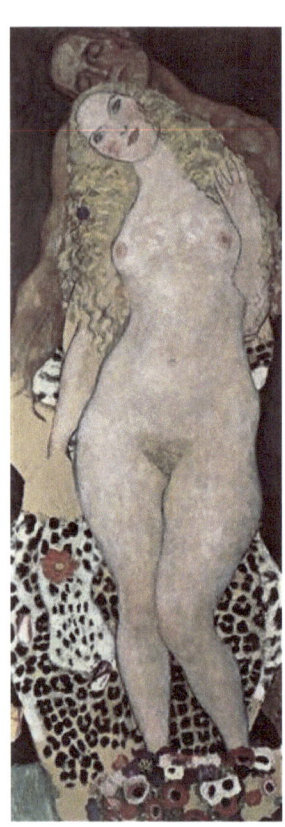

Adam And Eva (Unfinished)-- 1917-1918-- Art Nouveau (Modern)

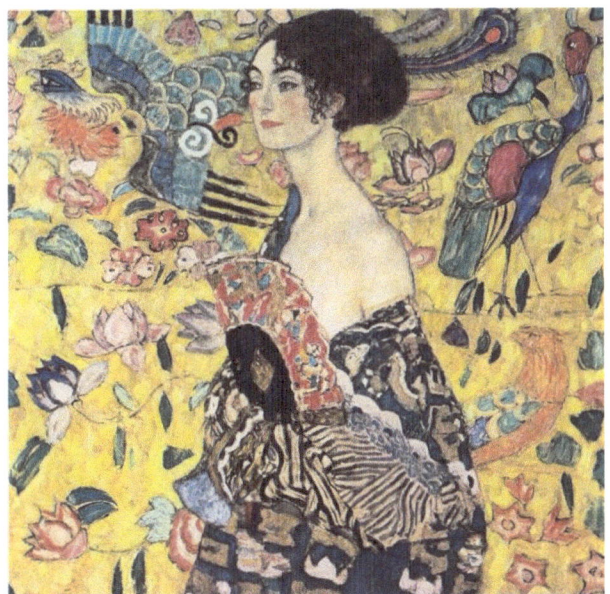

Lady With Fan-- 1917-1918-- Art Nouveau (Modern), Japonism

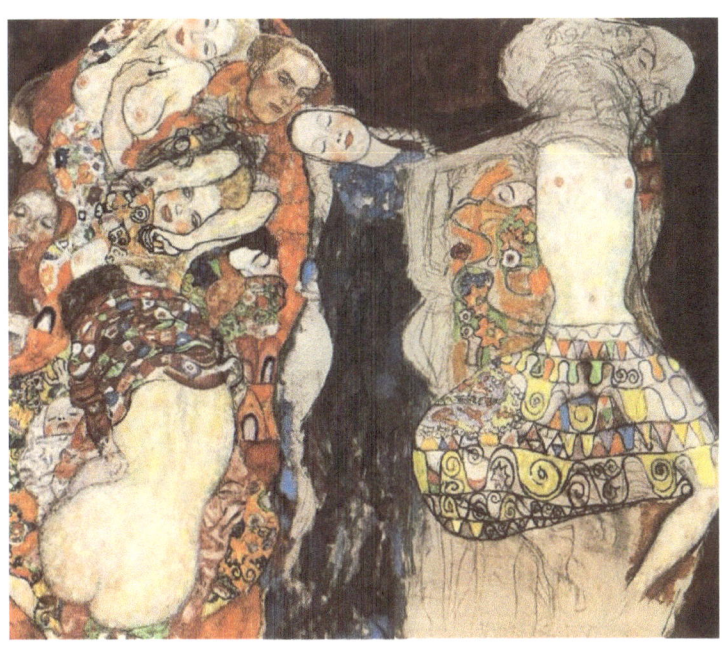

The Bride (Unfinished) -- 1917-1918-- Art Nouveau (Modern)

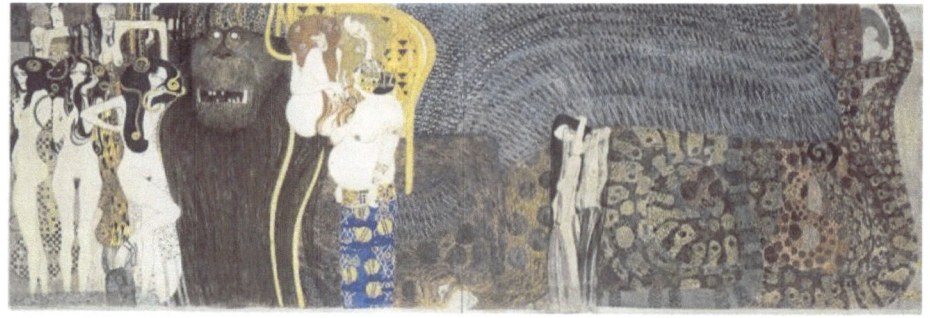

The Beethoven Frieze: The Hostile Powers. Far Wall—1902-- Art Nouveau (Modern)

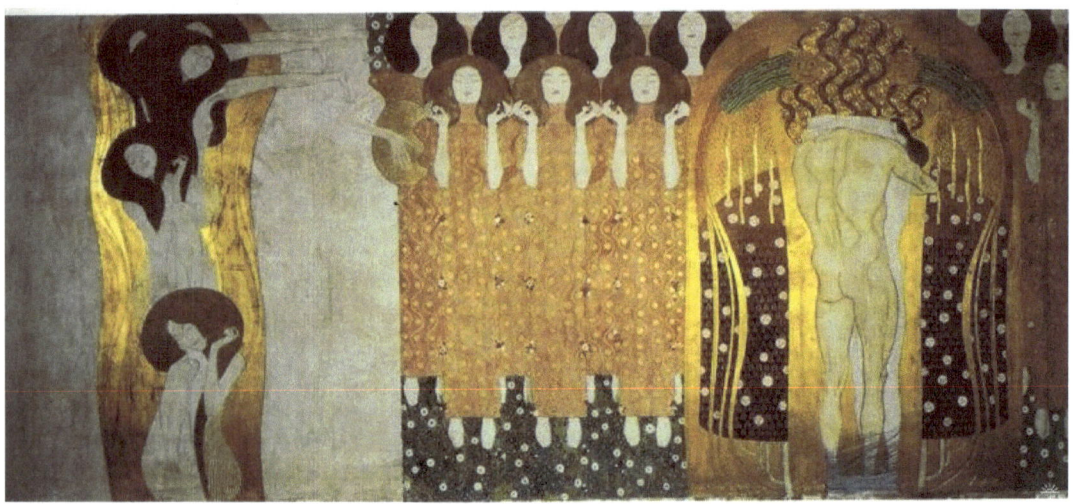

The Beethoven Frieze: The Longing For Happiness Finds Repose In Poetry. Right Wall—1902-- Art Nouveau (Modern)

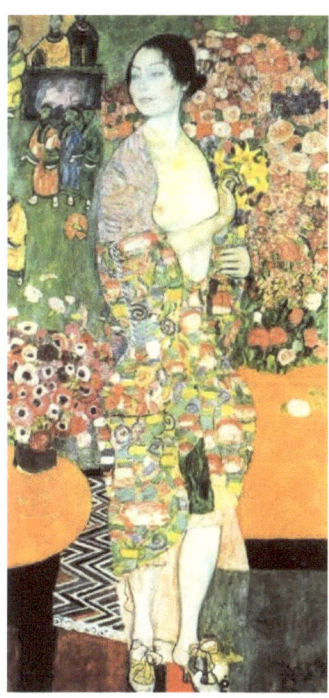

The Dancer

Originally Titled Die Tänzerin--1916-1918--Art Nouveau (Modern), Japonism

Female Nude--Art Nouveau (Modern)

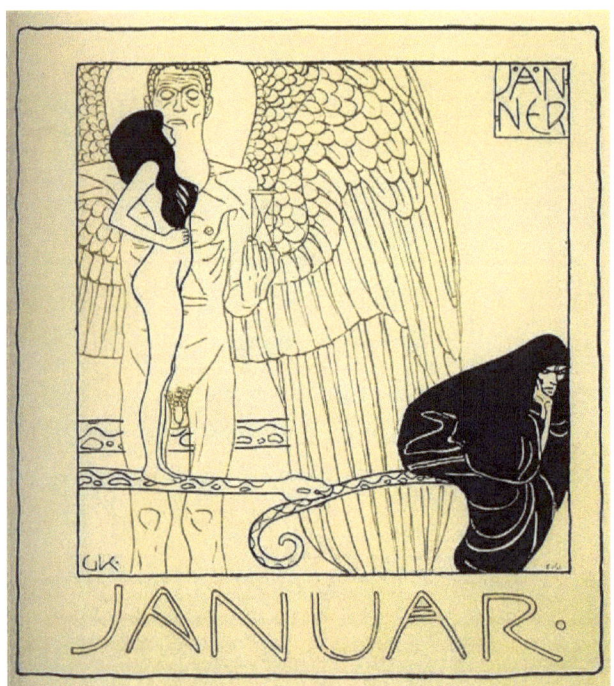

Januar-- Art Nouveau (Modern)

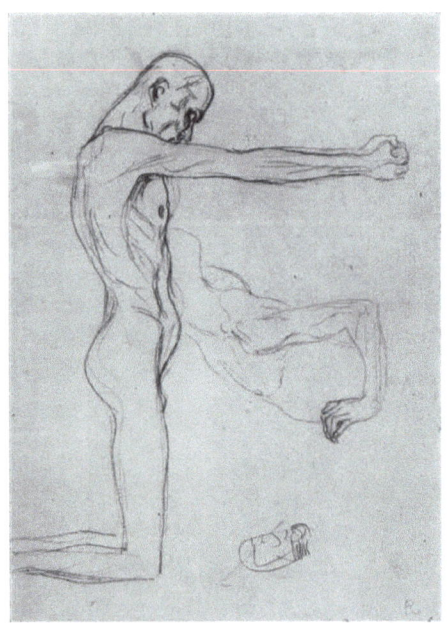

Kneeling Male Nude With Sprawled Out Arms, Male Torso-- Art Nouveau (Modern)

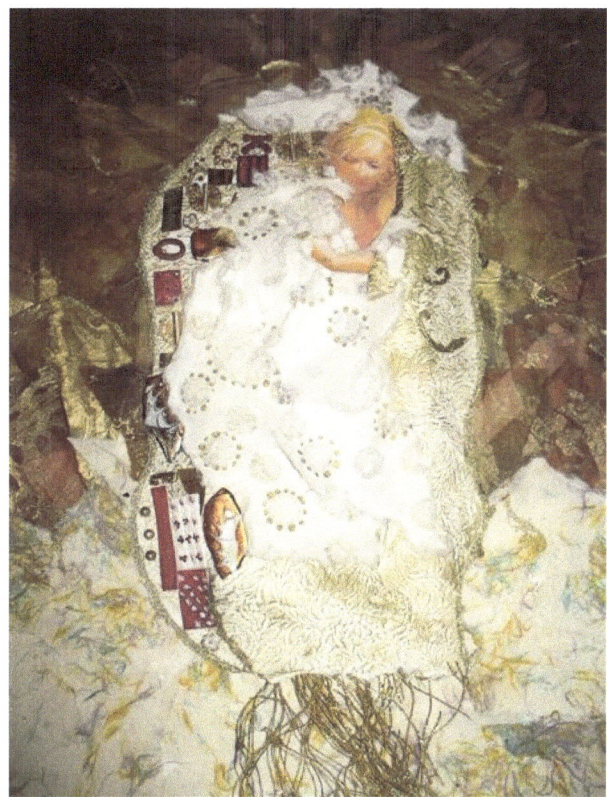

Ode To Klimt-- Art Nouveau (Modern)

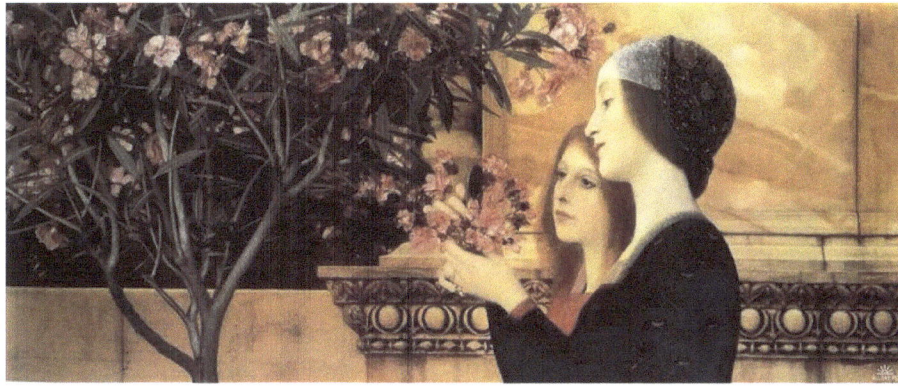

Two Girls With An Oleander-- Romanticism

www.ingramcontent.com/pod-product-compliance
Lightning Source LLC
Chambersburg PA
CBHW050408180526

45159CB00005B/2195